Compost
Critters

TEXT AND PHOTOGRAPHS BY
Bianca Lavies

DUTTON CHILDREN'S BOOKS
NEW YORK

This book is dedicated to all the critters in my compost pile; and especially to the little mother springtail I watched rescue her babies from a large puddle of water for them, a pinhead-size drop for me.

ACKNOWLEDGMENTS

For sharing time and knowledge:

Dr. Richard Sayre, U.S. Department of Agriculture, Science and Education Administration;

Dr. Suzanne Batra, U.S. Department of Agriculture, Beneficial Insect Introduction Laboratory, Agricultural Research Center;

Dr. James Vaughn, U.S. Department of Agriculture, Agricultural Research Service.

Library of Congress Cataloging-in-Publication Data

Lavies, Bianca.
 Compost critters / text and photographs by Bianca Lavies. — 1st ed.
p. cm.
Summary: Describes what happens in a compost pile and how
creatures, from bacteria and mites to millipedes and earthworms, aid
in the process of turning compost into humus.
ISBN 0-525-44763-6
1. Compost fauna—Juvenile literature. 2. Compost—Juvenile
literature. 3. Soil microbiology—Juvenile literature.
[1. Compost. 2. Soil biology. 3. Soil ecology. 4. Ecology.]
I. Title.
QL110.5.L38 1993
591.52'6404—dc20 92-35651 CIP AC

Published in the United States 1993 by
Dutton Children's Books,
a division of Penguin Books USA Inc.
375 Hudson Street, New York, New York 10014

Designed by Sylvia Frezzolini

Printed in Hong Kong First edition
10 9 8 7 6 5 4 3 2 1

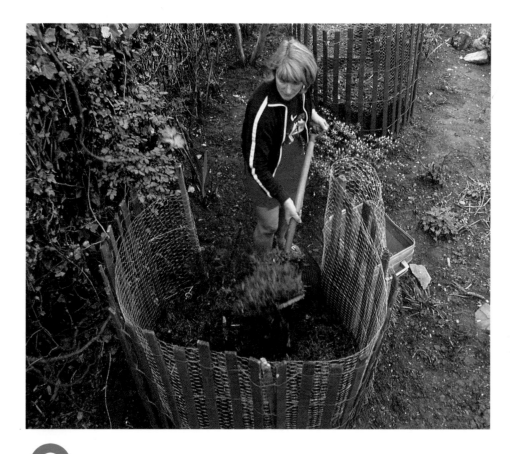

On a bright spring day, photographer Bianca Lavies is adding grass clippings to her backyard compost pile.

Weeks ago, she decided to improve the soil in her garden. Instead of giving her kitchen and yard scraps to the trash collector, she would make something new and valuable from them. She would build a compost pile. In a compost pile, her organic garbage—garbage from living things like weeds, leaves, eggshells, and fruit and vegetable leftovers—would change and change again. Eventually it would turn into a moist, dark, nutritious material perfect for plants.

This material is called humus. Without humus, the earth's soil would be little more than gravel and sand. Without humus, flowers, fruits, vegetables, trees—all the plant life on which animal life depends—could not grow healthy and strong.

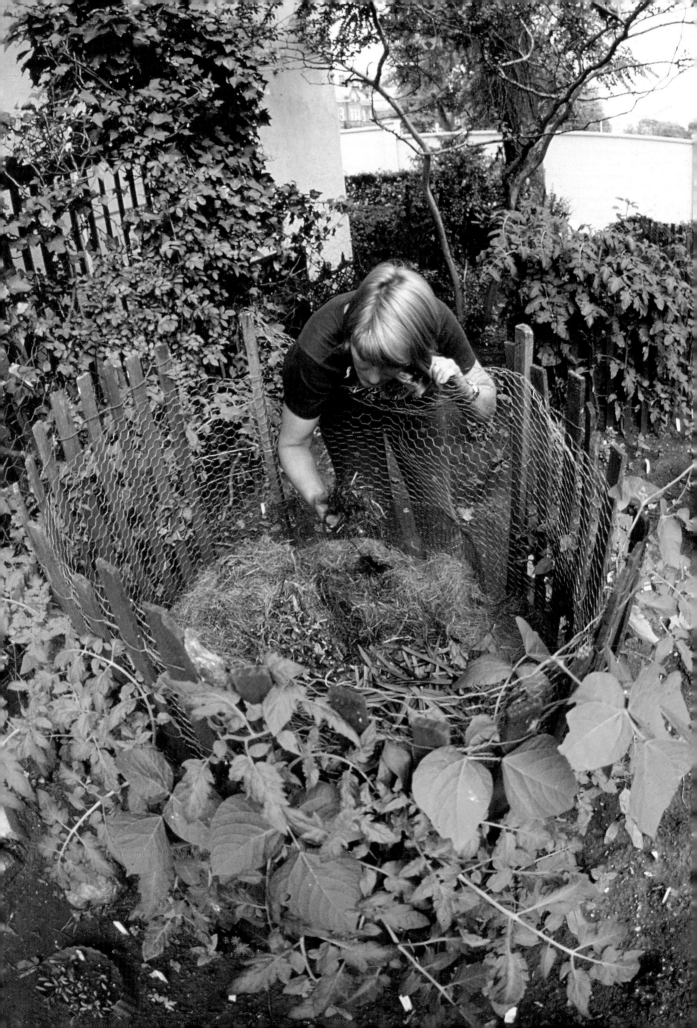

If you have seen fallen leaves, twigs, branches, or feathers rotting on the forest floor or in your backyard, you have seen nature's own compost pile. Nature wastes nothing. The plants and animals that die in a forest or field or garden are broken down in many stages by a process called decay. As they decay, the elements these once-living things were made of return to the earth and air. There they are used again, or recycled, by living green plants and all the animals—like us—that eat the plants.

A compost pile is a way of helping nature speed up the creation of humus—and a pile is a convenient way to do this, too, because farmers and gardeners can spread the humus where they need it. For her pile, Bianca built a sturdy enclosure of chicken wire and wood slats to hold the compost. Then she planted tomatoes and beans around the sides to see how a compost pile would affect them. She knew her heap would help the environment, but she didn't know—until she started to watch and take pictures—what a community of critters, from microscopic bacteria to snails and earthworms, would come through the air and soil in her yard to feast there. The organic leftovers that we humans consider garbage are a banquet to compost critters.

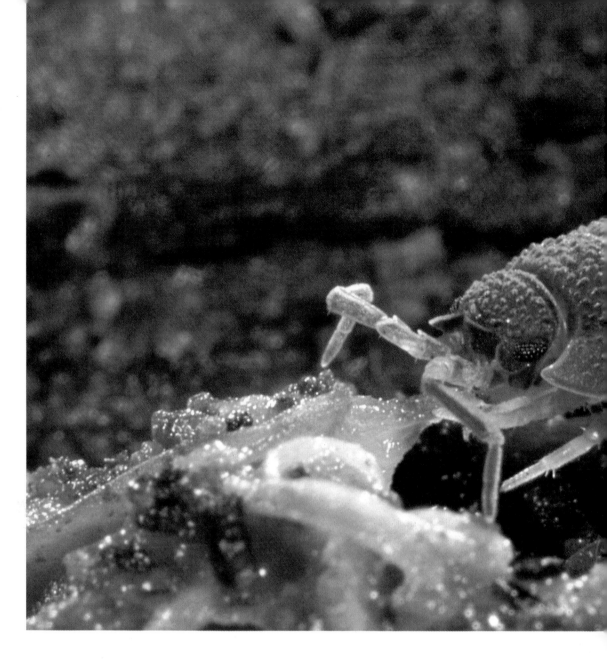

This half-inch-long sow bug is one critter attracted to the rich supply of food in the pile. It feeds on most plant material. As the sow bug goes about eating and digesting and then excreting what it does not need, its droppings (as well as those of other critters) help create the nourishing humus that is the final product of the compost heap.

Despite its name, the sow bug is not a bug. It is a crustacean, a relative of shrimps and lobsters. Hundreds of millions of years ago, its ancestors were among the first animals with jointed legs to leave the sea and adapt

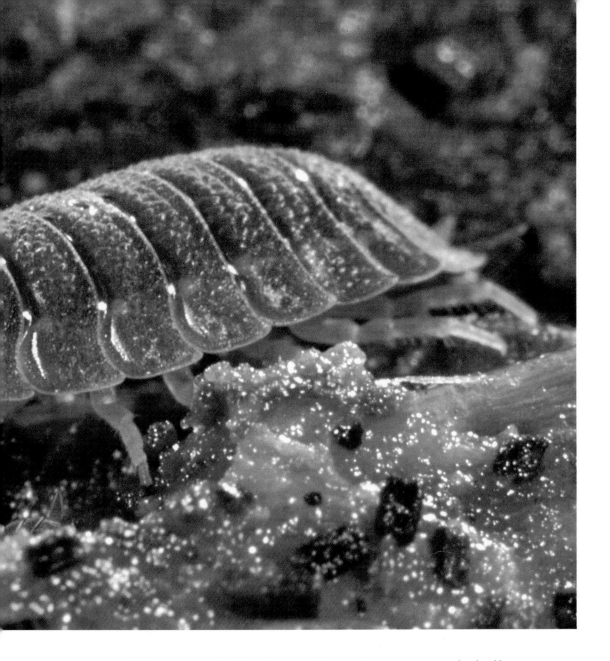

to life on land. In their gills and segmented shells, sow bugs show their kinship to their ancient relatives.

When you look at the compost community, you are looking at present-day offspring of some of the earth's earliest land-dwelling animals. Though compost critters may seem humble, the ways they find their food and break it down have allowed them to survive hundreds of millions—or even billions—of years on earth relatively unchanged, while other kinds of animals have come and gone.

Microscopic compost critters called bacteria have helped make this tomato mushy. They arrive early at the heap, carried by the air or already present on the waste dumped on the pile. These simple forms of life, each just a single cell, live everywhere—in the soil and air, on and even inside plants and animals. Bacteria are the primary reason that an apple core cast into a field will soon disappear and that flower stalks left on the ground will rot away. And that a compost pile properly cared for will eventually turn into humus. Bacteria digest the remains of plants and animals for their own energy, generating heat and releasing important nutrients in the process. Some kinds of bacteria do this in your gut, too—helping with the breakdown of the food you eat.

Bacteria were among the first forms of life on earth, so they have had plenty of time to specialize in the art of decay. Billions of them quickly grow and reproduce throughout the pile, some thriving in the high heat at the center, others in the cooler outer layers; some extracting nourishment from grass clippings, turning them brown and watery, others feeding on discarded vegetables, like this tomato.

And as you can see, the mushy, decomposing tomato also provides a nourishing environment for larger compost critters.

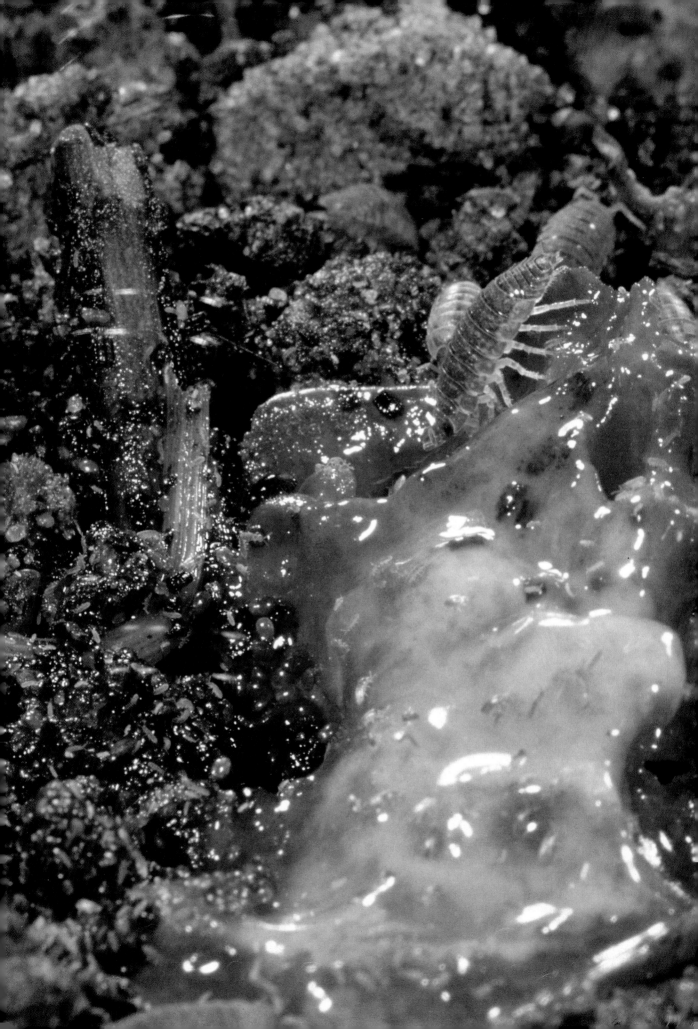

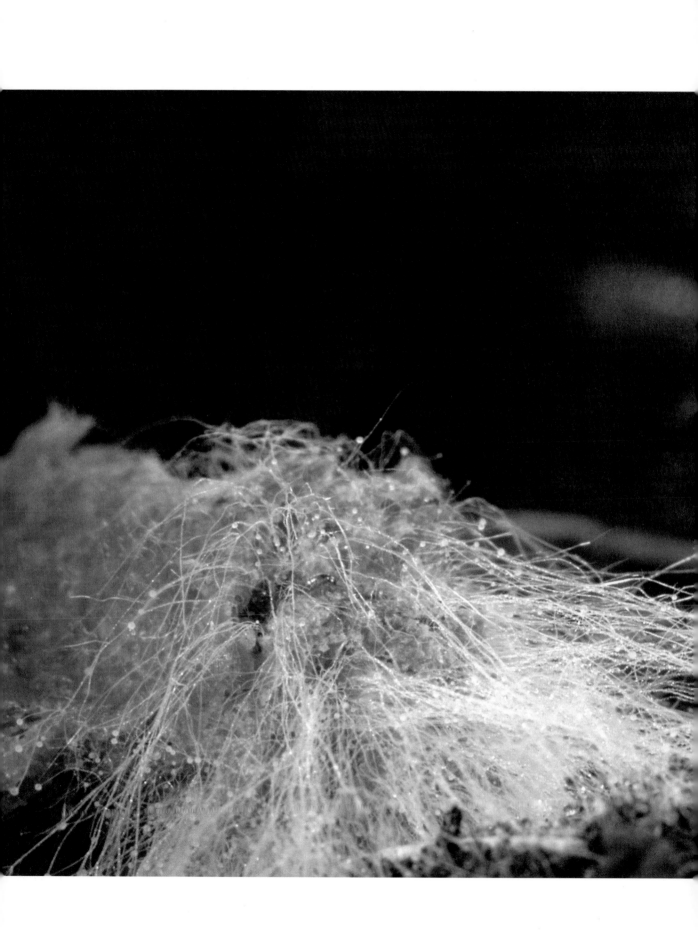

This spooky threadlike thing is a mold, a kind of fungus. Along with bacteria and other microscopic organisms, fungi are another powerful group of decomposers. They feed on different kinds of plant material, at different places and temperatures in the pile.

This mold is turning a piece of old bread to liquid. Those white hairy-looking things are fine tubes called hyphae. They secrete a substance, an enzyme, that dissolves the bread. Then the fungus absorbs the liquid nutrients through its hyphae. Some fungi also make special poisons that kill certain bacteria with which the fungi compete for food in the pile. Penicillin, used in the treatment of a variety of infections, is one such "poison."

Many animals—including some critters in the pile—eat fungi. We eat fungi, too—in the form of mushrooms.

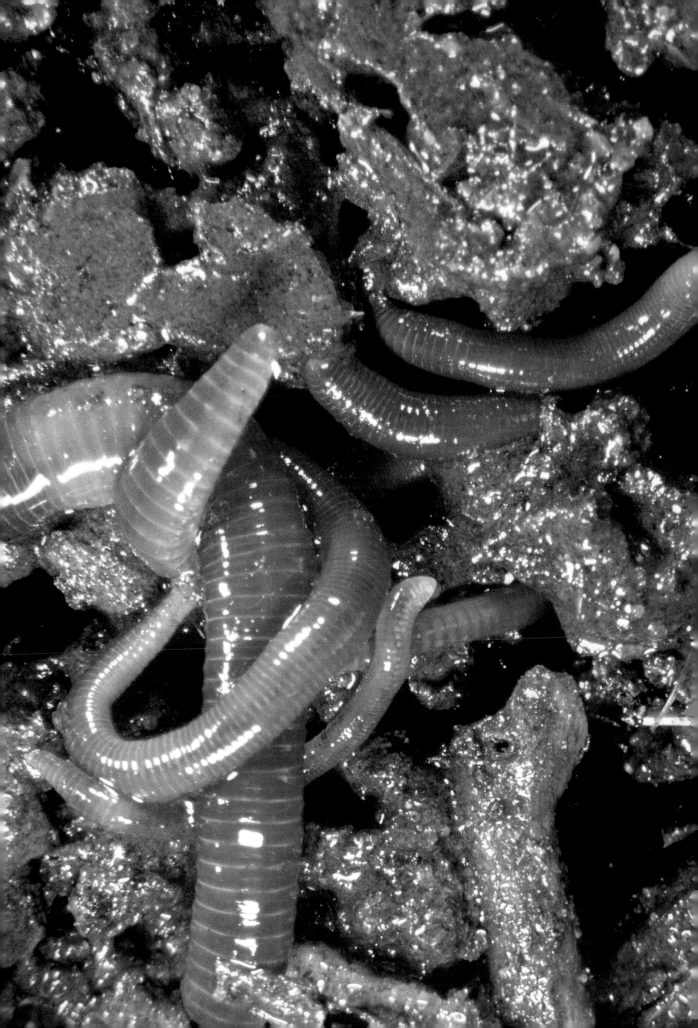

While the bacteria and fungi are doing their part, earthworms zero in. The compost heap is soon crawling with these valuable creatures.

As they tunnel through the ground, earthworms suck soil into their mouths—and plenty else along with the soil: bacteria and fungi, bits of decaying plant material, even small stones and fragments of glass. Worms do not chew all this—they have no teeth. Instead, they have a place in their digestive tract, called a gizzard, that contains sand and other mineral particles. As the worm expands and contracts, wriggling along in its wormy way, these hard particles grind up what the worm has swallowed. Then the worm's digestive juices go to work.

The worm casts out what it does not need for nourishment in tiny pellets called castings. Small though they are, these castings are the basis of the humus the compost heap creates. They are extremely high in minerals and organic materials.

Earthworms are the untiring plows of the pile. Their constant tunneling turns over and loosens the compost, allowing water and air, vital to all the compost critters, to circulate.

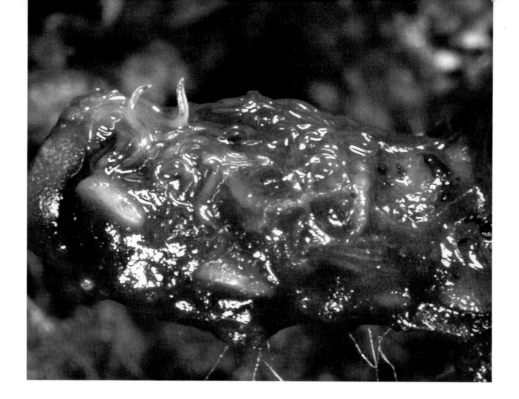

If you scoop up a handful of compost, you will also be holding millions of tiny wriggling round worms called nematodes. Unlike the large segmented earthworms, most nematodes can be seen only with a magnifying glass.

The nematodes above are devouring a dead millipede. Within two days they have eaten all its soft parts. Only the millipede's tough outer skeleton remains, nibbled clean enough for a springtail to explore *(bottom and, through a microscope, right)*. Fungi and bacteria will finish

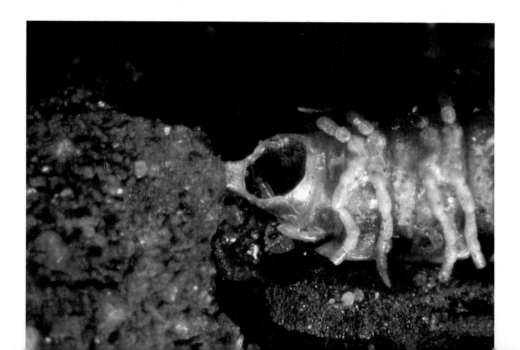

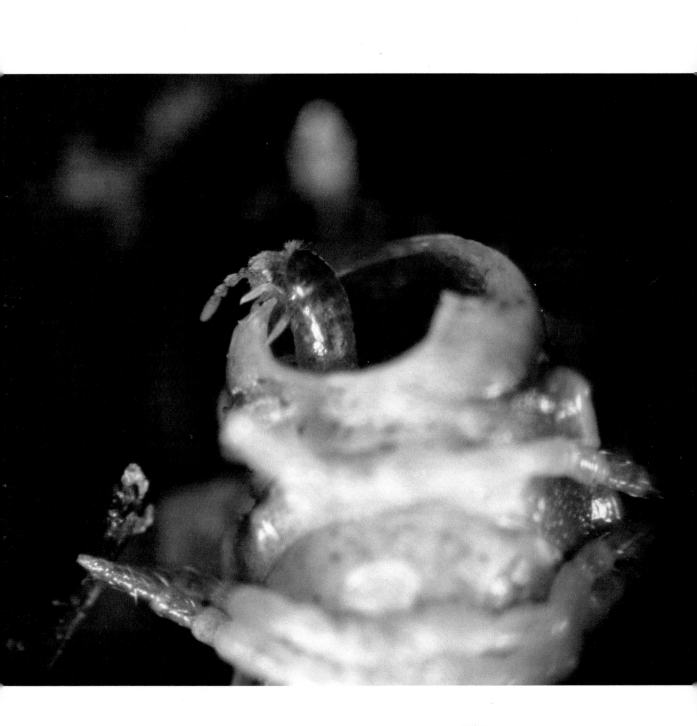

off the hard shell, or exoskeleton, until not a trace of
the millipede is left.

Nematodes eat almost any dead organic matter
available; some eat bacteria and fungi as well. Sometimes
they also attack the roots of living plants, or even one
another. And springtails, in turn, eat nematodes.

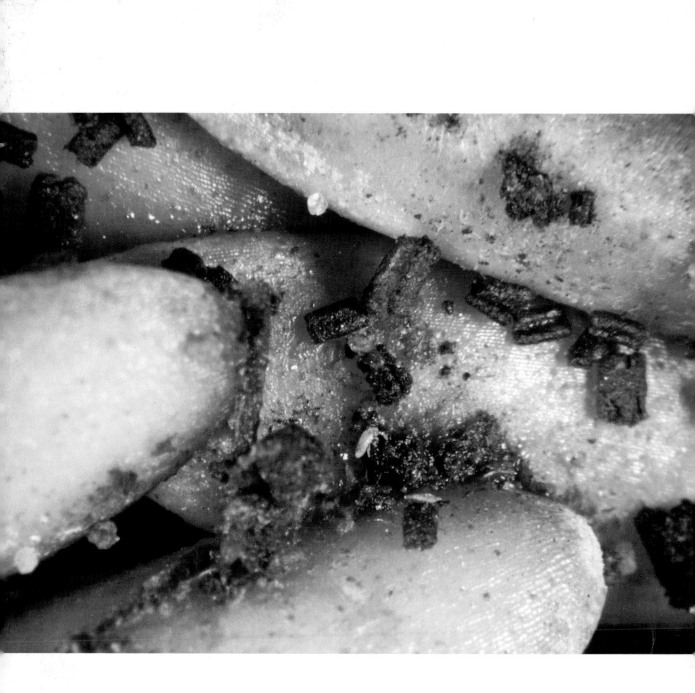

Can you find the tiny springtail among the droppings
on these discarded cantaloupe seeds? Springtails are
members of a large group of animals called Arthropoda,
animals with jointed legs. Relatives of springtails were
among the first insectlike animals to evolve on earth,
and they have been colonizing its territories ever since.
Huge numbers of springtails live in all layers and types
of soil, from the Arctic to the tropics. They are even
found in Antarctica.

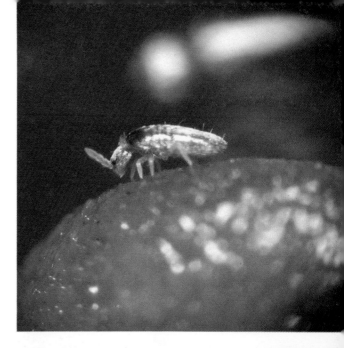

A springtail springs into the air, but it doesn't use its jointed legs to do so. Instead, folded under its abdomen, neatly held by a springlike catch, is a forked lever *(top right)*. Released instantly at the slightest threat, the lever snaps down hard against the surface below *(middle)*, catapulting the springtail a distance more than a hundred times its own length.

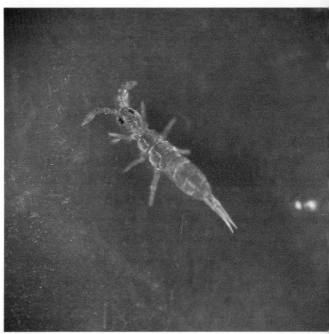

Springtails eat decaying matter of all kinds, as well as nematodes and fungi. When they are done eating, they "lick" their hairy bodies like cats *(bottom)*.

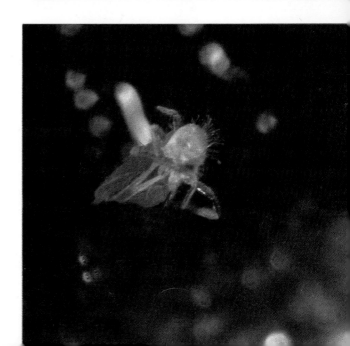

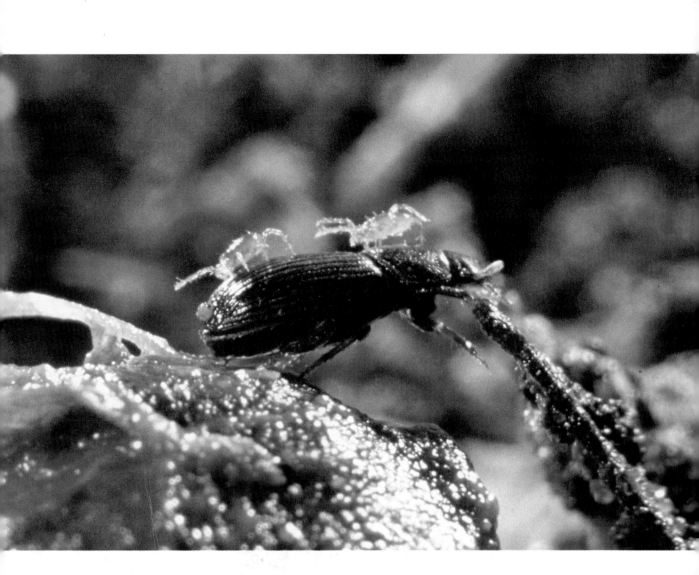

Two shiny amber-colored mites, each smaller than a grain of sand, have hitched a ride on this hister beetle crossing a crevice in the compost heap. Then a bundle of speck-sized young mites, or nymphs, comes aboard. These tiny creatures travel more quickly as stowaways than they would on their own.

With their tubular bodies and eight jointed legs, mites are easy to recognize under a magnifying glass. They belong to the class Arachnida, which includes spiders and scorpions and is part of the larger animal group Arthropoda.

Scientists have identified more than one million kinds of mites. Mites eat decaying organic material as well as living microscopic organisms in the compost heap. Some eat insect larvae. And some mites are parasites, sucking their nourishment from insects, birds, and mammals. Perhaps your dog has come home after a run in the woods with a tick embedded in its flesh. The parasitic tick is a relative of the mite.

The hister beetle makes its meals out of live animals like the compost critters, so it has found a good place to hunt. Its droppings will nourish the pile, too.

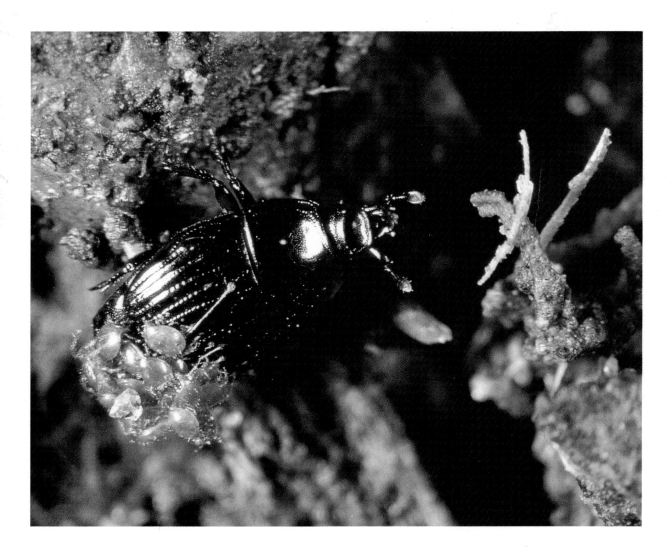

Mite nymphs caught a ride on another arthropod, a millipede, now curled up to rest. *Milli* means thousand and *pedes* means feet, but millipedes do not have a thousand feet. Some do have as many as one hundred, though, and they travel smoothly across the contours and crevices of the compost heap. Millipedes belong to a class of animals called Myriapoda, which means many-footed.

Millipedes eat plant material, and they are attracted to the damp, dark outer layers of the heap. To hide from predators such as birds, beetles, and other insects (or from a photographer's light), these inch-long creatures scurry under leaves, stones, or whatever is handy.

If millipedes look like small prehistoric creatures to you, that's because they are. Fossils show the first millipedes appeared on earth roughly four hundred million years ago, long before dinosaurs walked the land.

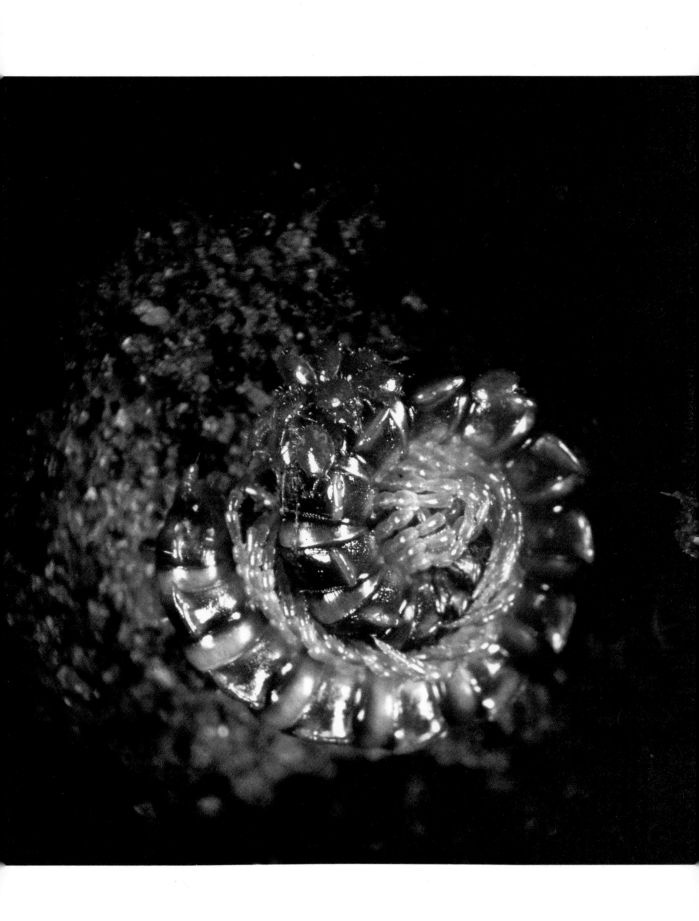

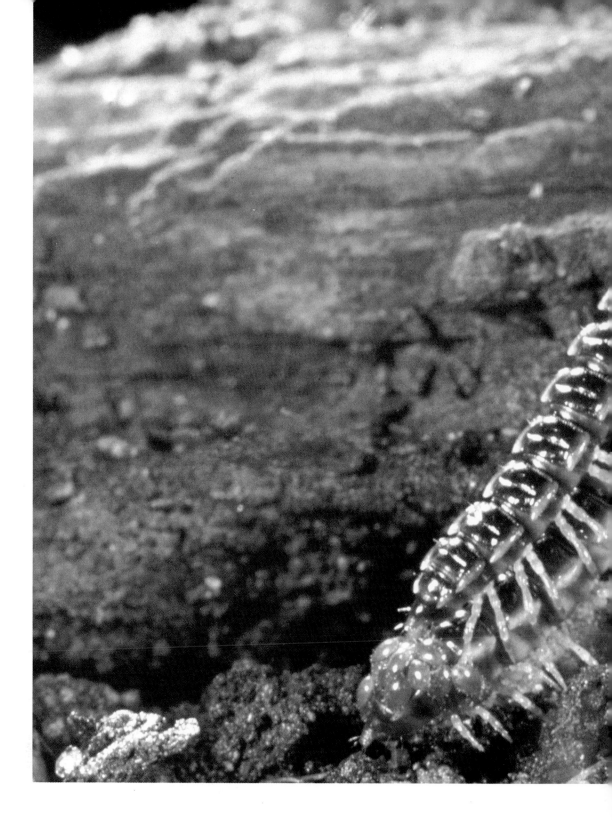

For a few weeks in August and September, the millipedes in the compost heap and in the garden traveled and ate in pairs, one on top of another. These pairs even carried—triple-decker-style—their mite passengers.

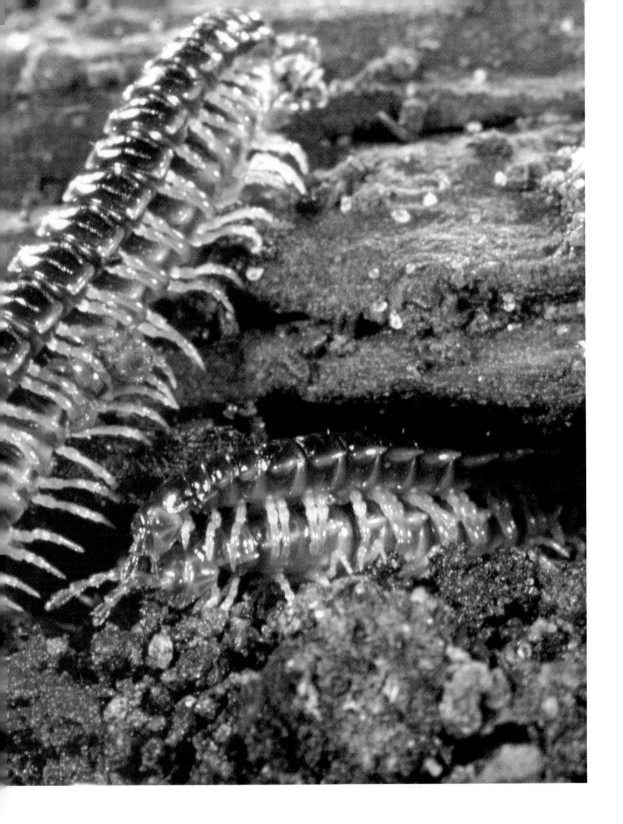

What was happening? Bianca called the Smithsonian Institution, in Washington, D.C., to find out. "That's love," explained a scientist.

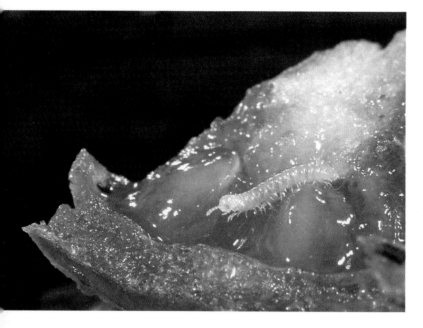

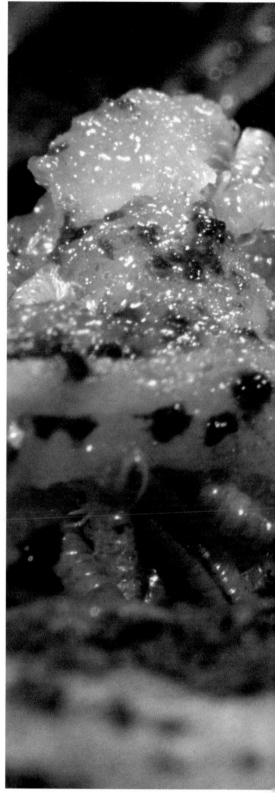

Sure enough, the piggyback rides were apparently part of millipede courtship. In November, hundreds of tiny white millipedes appeared in the compost pile. They feasted on the remains of tomatoes, cantaloupes, and other kitchen leftovers.

The young millipedes will shed their skins, or molt, several times before they acquire the dark protective exoskeleton and full set of legs of the adults. Now they are on their own. Their parents do not protect them from predators, which include centipedes, beetles, and ants.

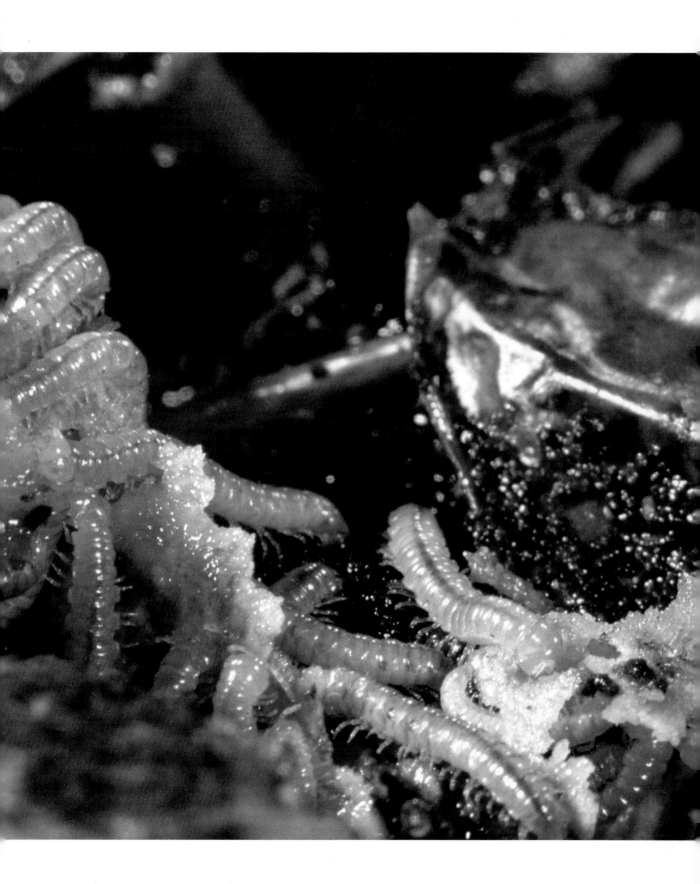

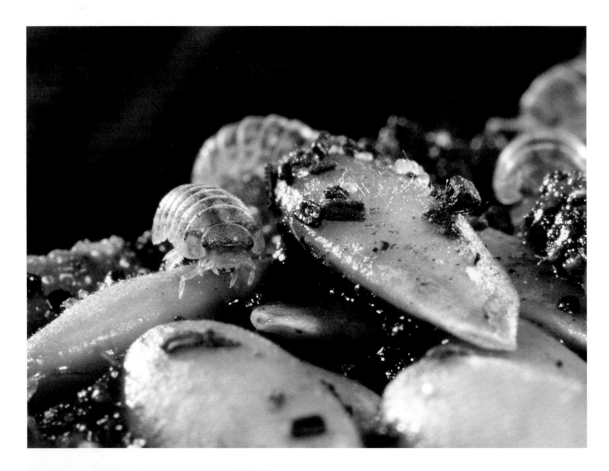

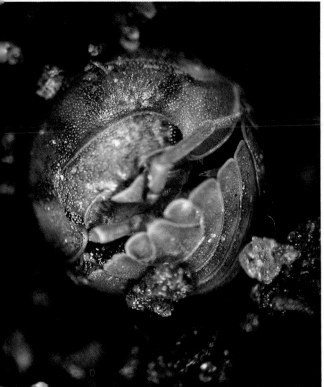

Sow bugs *(above and right)* and their cousins the pill bugs *(left)* — compost crustaceans both — scavenge the damp layers near the surface of the pile.

The sow bug on the right is exploring slug eggs. But it won't eat them. Sow bugs and pill bugs eat only plant material, like leaf litter, vegetable scraps, and rotting wood. Most people cannot tell these fingernail-sized creatures apart. But pill bugs roll into a tight pill-like ball when they are disturbed. Sow bugs do not.

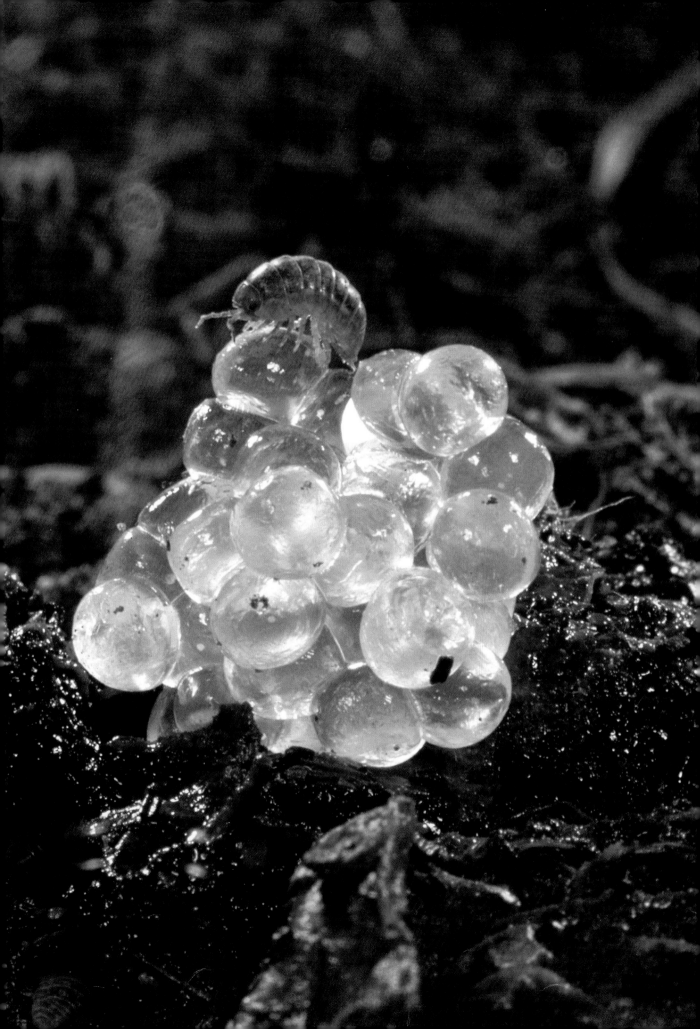

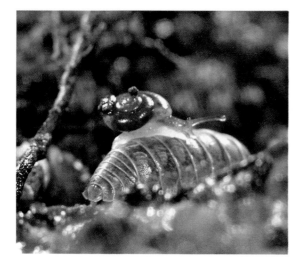

Adult land snails travel about two inches per minute, moving gracefully on trails of slime. In the compost heap, this elegant baby snail has climbed atop a pill bug to get around more rapidly. The snail reminded Bianca of a passenger getting off and on buses: When it wants to eat, it just slides off; when it wants another ride, it climbs onto the next passing pill bug.

Snails, like bacteria and fungi, are able to digest cellulose, the material that reinforces the rigid walls of plant cells. They use their rasplike tongues to scrape up particles of plant material in the pile.

Springtails and mites eagerly devour the fresh snail droppings, further breaking down organic material.

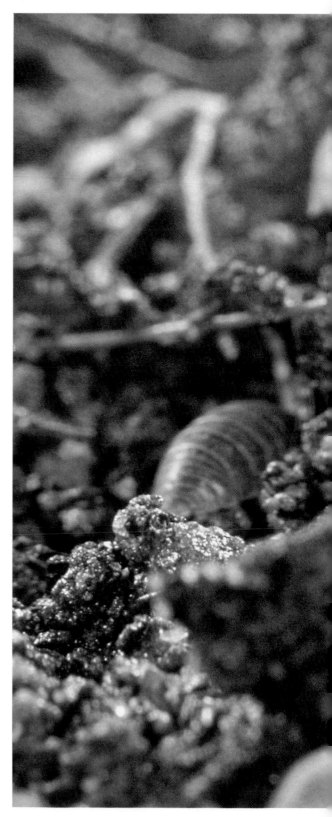

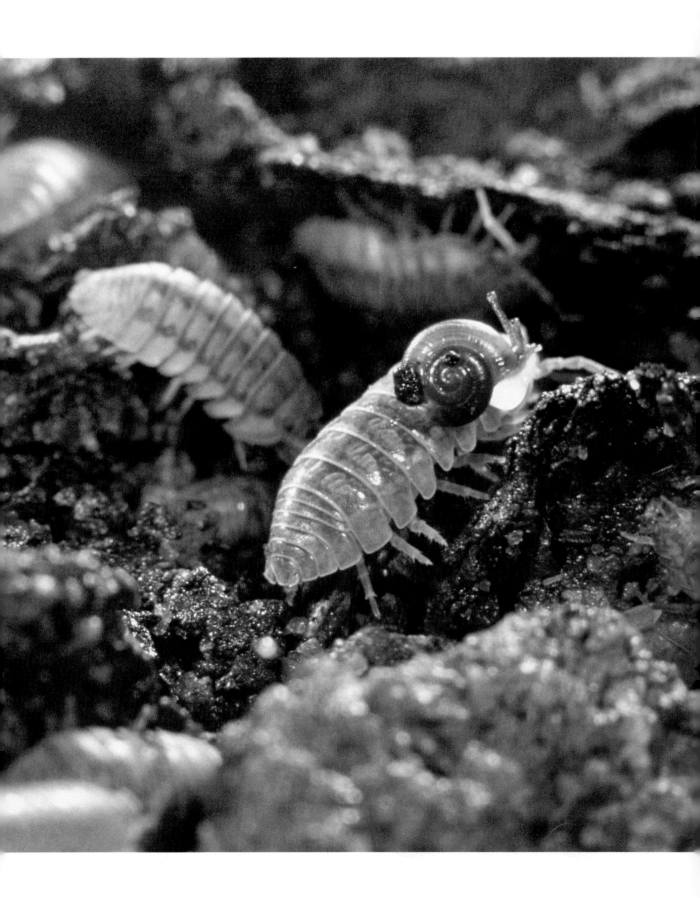

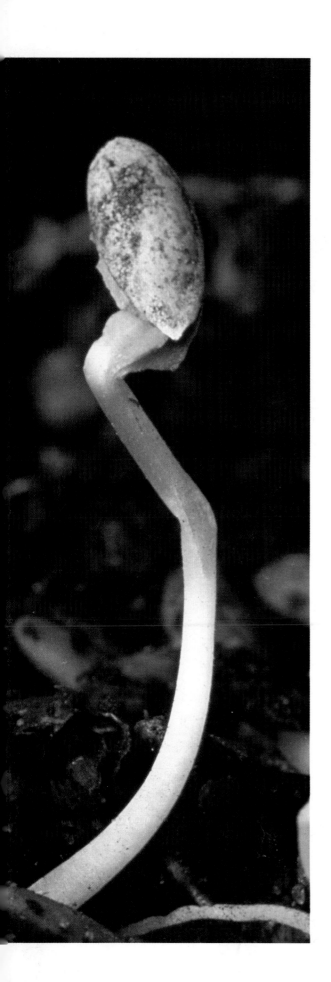

As summer progresses, new plants grow from old life. The high heat at the center of the pile destroys many seeds. But here on the outer edge of the heap a cantaloupe seed has sprouted a shoot. Nearby hangs a ripe cantaloupe, waiting to be picked. A fruit fly sits on another shoot, overseeing it all.

Fruit flies are attracted in large numbers to the sweet-smelling fruity "stew" of the compost heap (fruit cooked in syrup is often called a compote). They dine and lay eggs, living only two weeks as adults.

Depending on how warm spring and summer are, and how much rain there is, in about nine months all the compost critters will have turned Bianca's organic garbage to humus, ready to be spread in her garden. She will tend her pile year-round.

During autumn, she will add fallen leaves. In winter, she'll continue to dump fruit and vegetable scraps, coffee grinds, and wood ashes there.

What will the critters do? Frost will make the bacteria and fungi inactive, but they will not die. The earthworms will burrow deep down and roll themselves up in little self-made holes. Even during the first frost, springtails and millipedes will still be active in the heap. But before the earth hardens for winter, they and the rest of the critters will find nooks and crannies in the compost pile or elsewhere in the yard. There they will rest. They will not eat or move around, but they will not die. When spring comes, they will be, once again, busy compost critters.

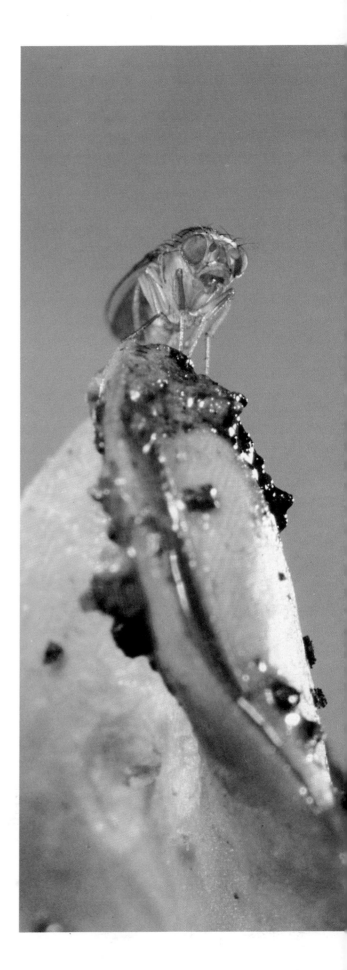

2/23/94

Wellfleet Public Library
~~RR.1~~ West Main Street
Wellfleet, MA 02667
500-349-0310